...

...

From:

...

...

Weddings

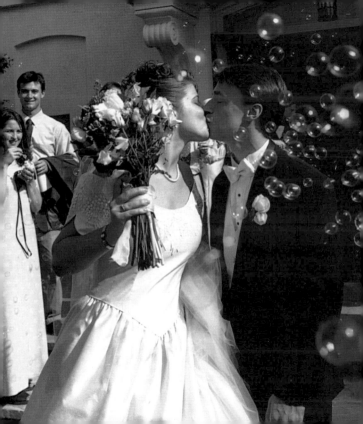

Weddings

Timothy Murphy

a miniSeries book
Abbeville Press Publishers
New York ÷ London ÷ Paris

Contents

෩

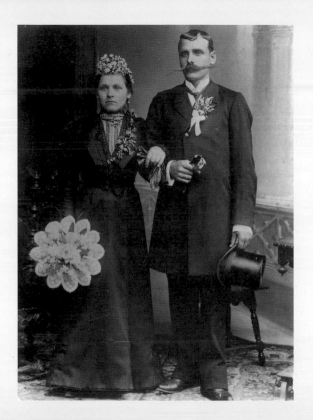

Introduction

છા

Charles Darwin didn't put matrimony very high up on his evolutionary ladder. Ever the scientist, in the 1830s, as a bachelor considering marriage, he sat down to weigh the advantages of remaining single versus tying the knot. Among the former, he listed "freedom to go where one liked" and "not forced to visit relatives, or bend to every trifle." And in defense of marriage? An "object to be beloved & played with," he figured, " –better than a dog anyhow."

Hardly romantic words, yet they get at some of the fundamental anxiety and ambivalence that surrounds what is perhaps life's most monumental passage—the wedding day. The popular imagination seems to be full of images of runaway brides and stand-ups at the altar: Dickens's Miss Havisham

jilted by her groom and ever after bitter toward all men, crumbling away in a dark house, her wedding cake a grim temple of mice and cobwebs. Dustin Hoffman interrupting Katharine Ross's nuptials at the last minute to free her from the unhappy bonds of matrimony.

That reluctance doesn't seem to be limited to the western world either: among the Bajju of Nigeria, a girl weeps bitter public tears en route to her wedding because it would be considered taste-less and shocking if she looked happy about her fate. Ambivalence is thus ritualized and given free expres-sion, something Anne Morrow might have appreci-ated when she wrote to a friend of her impending wedding to Charles Lindbergh: "Don't wish me happiness . . . wish me courage and strength and a sense of humor—I will need them all."

And yet, despite all the jokes and fears, despite the fact that many women once met theirs with dread and many men still do, weddings continue to

take place as they have for centuries. Across eras and hemispheres, weddings have remained notably the same: the day when two people pledge to live the rest of their lives together in the eyes of their family, friends, religion, and state (or some combination thereof). Such hardiness begs the question: with all the cultural changes of the past few decades— greater sexual freedom, women's increased economic independence, soaring divorce rates, declining attachments to religion—why do people still go on having weddings? Love is probably at the center of the answer—but more on that later.

Why else? For one thing, everyone loves parties, both hosting and attending them, and a wedding is an opportunity (or even an excuse!) to throw perhaps the biggest party of a lifetime. The 1613 wedding (or, you might as correctly say, production) of England's Princess Elizabeth and Bohemia's Prince Frederick involved mock naval battles on the Thames featuring thirty-six ships, five hundred

sailors, and one thousand musketeers; fireworks exploding above four floating castles; giant puppets of Saint George, a beautiful maiden, a fire-eating dragon (all of which eventually burst into flames to the delight of onlookers); and an assortment of masked balls, theatricals, and other spectacles. When all was said and done, the royal exchequer was completely bankrupt and King James was forced to levy taxes to help make ends meet. On the other end of the spectrum, John Lennon and Yoko Ono fled to Gibraltar for their 1969 wedding, a private ceremony during which both wore white tennis shoes and dragged on cigarettes. In between those poles, of course, there's no end of room for all sorts of celebratory self-expression, which is amply represented in the following pages.

Then there is The Dress, to which, in fact, the first section of this volume is devoted. For if a wedding gives license to throw the ne plus ultra of bashes, it also gives the bride license to wear the

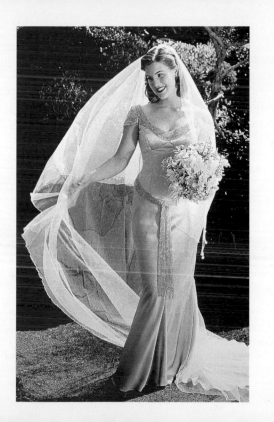

ensemble of her life, to dress for a day in a manner otherwise reserved for royalty—or, perhaps, very tasteful Vegas showgirls. Ask seasoned wedding-goers what element of a wedding they exert the most judgment upon, and surely if they're honest they'll name the bride and her appointments.

Some brides meet the challenge: Lady Diana certainly did in her world-witnessed 1982 marriage to Charles, Prince of Wales, for which she wore a virtual float that would have left Cinderella at the height of her enchanted evening looking downright frumpy. In her own way, John F. Kennedy, Jr.'s bride, Carolyn Bessette, did the same when she turned bridal fashion on its head by eschewing bows and bibelots for the simplest of sheaths, as artfully inconspicuous as the couple's secret island ceremony. Wallis Simpson thumbed her nose at her unaccepting in-laws when, at her 1937 marriage to Edward, Duke of Windsor (who gave up the throne to take the twice-married Simpson as his bride), she

wore a two-piece silk crepe Mainbocher number in what she would popularize as "Wallis blue" . . . along with a wedding ring of Welsh gold, the same kind worn by British queens.

But of course weddings aren't just about fashion. Much more than the union of one couple, they are also the time when families affirm their bonds (for better or worse!), when the passage of time is marked, and, often, when onlookers are moved to reflect on their own lives. The focal point of the enormously popular film *Four Weddings and a Funeral* wasn't about those four weddings per se, but about a group of friends who attend them over a period of time, about their own tangled feelings over intimacy and independence, freedom and commitment. There we all are, smiling our Sunday best smiles as we privately reckon with our own lives, in counterpoint to the day's main event—the bride and groom's public declaration of union.

Public, yes—yet in the end, the true allure of

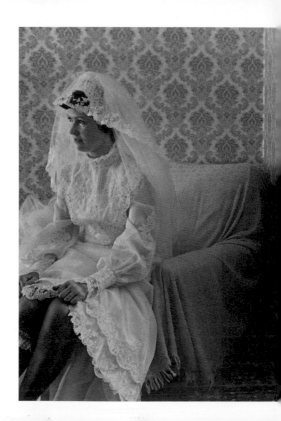

14

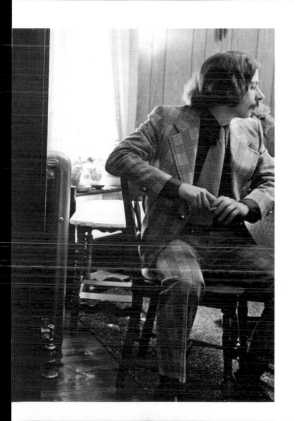

weddings are the things not meant for public consumption: a glimpse of those off-the-record flashes of vulnerability and intimacy between a truly besotted bride and groom. These are the moments that affirm what the romantic in all of us would really like to believe—that, more than a family imperative or an adherence to the social code, a marriage is a contract of faith and love legible to no one but its co-signers, a mutual promise that transcends the traditionally appointed roles of "husband" and "wife."

In Puritan America, when even married couples weren't allowed to show affection toward each other in public, some engaged couples were still permitted to "bundle" together in bed (separated by many layers of blankets and a "bundling" board). This way, a visiting future groom didn't have to make his way home in the cold, and the future bride's family could save on kindling, relying instead on body heat. For couples who actually managed to stay separated by

the board until their wedding night (and not all did—babies born before marriages were not uncommon among the Puritans), we can only imagine what private thoughts they shared amid the public affair of their wedding day.

And anyone who thought the Puritans were devoid of conjugal passion should note well the forty-four year marriage of poet Anne Bradstreet and her husband, Simon. Her 1650 poem to him ardently began:

> *If ever two were one, then surely we.*
> *If ever man were lov'd by wife, then thee;*
> *If ever wife was happy in a man,*
> *Compare with me ye women if you can.*

Four simply stated lines, and yet they hint at the same current of love and kinship, of erotic contentment and daily companionship, that we can hear murmuring just beneath the surface of the best

of wedding celebrations. That same current is suggested by the courtship of Alexander Graham Bell and his deaf student-turned-wife Mabel Hubbard, who would talk aloud to her beau on their evening walks, then pause under a lamplight to read the response on his lips. Or that of Queen Victoria, who secretly rhapsodized in her diary of her 1840 wedding night with Prince Albert: "I never never spent such an evening! He clasped me in his arms and we kissed each other again and again!"

F. Scott and Zelda Fitzgerald whooped it up so much on their 1920 honeymoon at New York City's Biltmore Hotel that the management asked them to leave—an early sign of the brilliant partnership in crime that would spike their marriage with record highs and lows. And of her marriage to Humphrey Bogart on May 21, 1945, Lauren Bacall wrote: "It seemed that everything that had ever happened to me had led to this day with him." Bogie, in a gray tweed suit with a white carnation in his lapel to

match Bacall's white orchids, was no less moved; Hollywood's quintessential tough guy cried throughout the entire three-minute ceremony.

Those private moments, the ones that tell more than any fact-filled wedding announcement in a newspaper ever could, are captured in this book with an eye that's at once respectful and revealing. A pre-ceremony bride who sits with a look of bemused patience while someone adjusts a crown of flowers in her pre-Raphaelite tresses. The focused, sober eye contact between a bride and groom as they exchange rings under a lush arbor, the presiding minister looking on sternly. The radiant smiles of a couple as they are chauffeured away from the ceremony toward their honeymoon, their faces alive with conspiratorial triumph.

These images and more are the true, sexy lures of a wedding, the ones that defy easy sentiment and find a place for themselves amid the complicated protocol of gift registries, guest lists, wedding

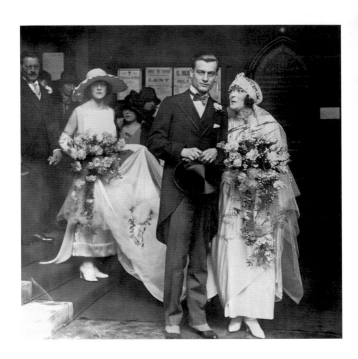

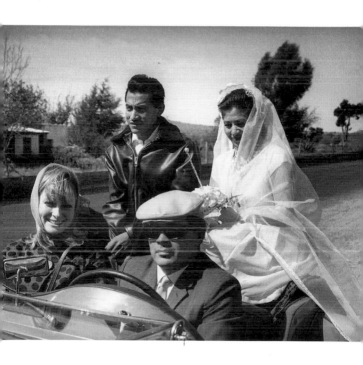

21

party assignations, or whatever the particular nuptial customs of a culture might be. No less an anti-sentimentalist than Darwin himself finally conceded as much when, after much scientific deliberation, he married his first cousin Emma Wedgwood in 1839. Her deep religious faith prevented her from accepting his views on evolution, but not from proofreading his *Origin of Species* before its publication. For her devotion, which he returned in kind, he called her "my greatest blessing" long after their January wedding day—the end of which found them fleeing their guests on a train to London, munching on sandwiches and toasting their future with bottled water.

How has the wedding evolved since then? Press on and take a look. . . .

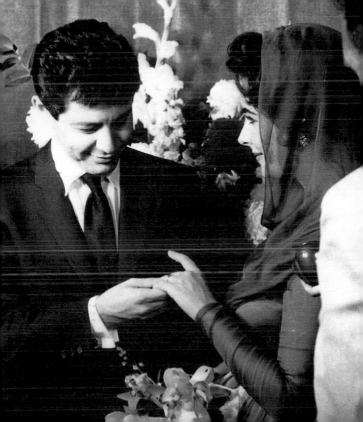

The Dress

Exuberance is beauty.

 ⇛ William Blake

ABOVE: Virginia, 1996.
OPPOSITE: New York City, 1995.

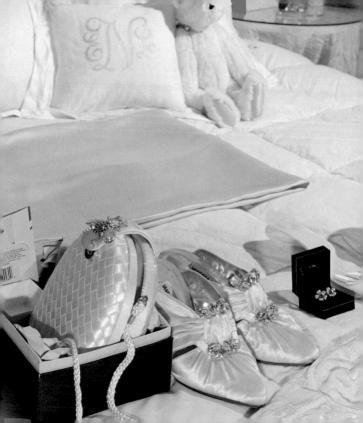

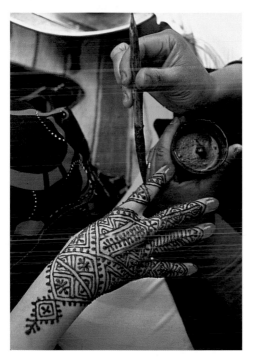

ABOVE: Morocco, 1977.
OPPOSITE: New York City, 1995.

29

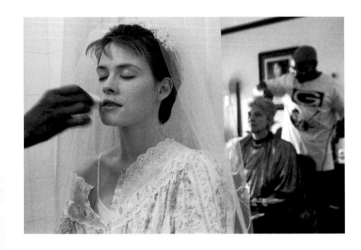

ABOVE: New York, 1994.
OPPOSITE: New York City, 1998.

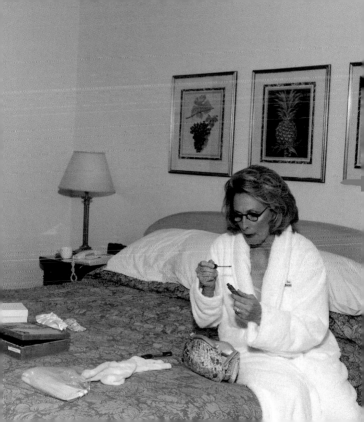

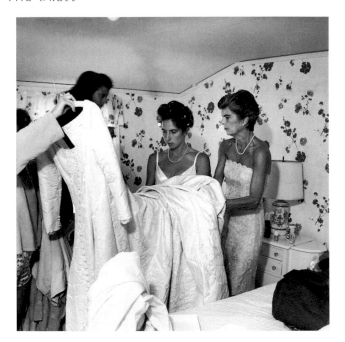

Martha's Vineyard, 1990.

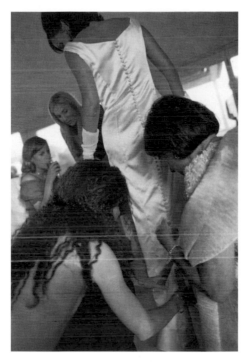

The Hamptons, New York, 1997.

*D*eck thyself maiden,
With the hood of thy mother;
Put on the ribands
Which thy mother once wore.

ෆ Estonian bridal song

Cold Spring, New York, 1997.

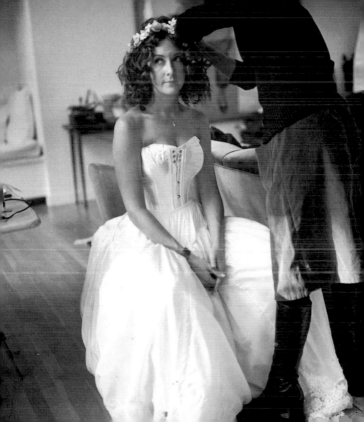

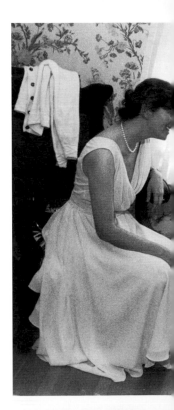

Massachusetts, 1991.

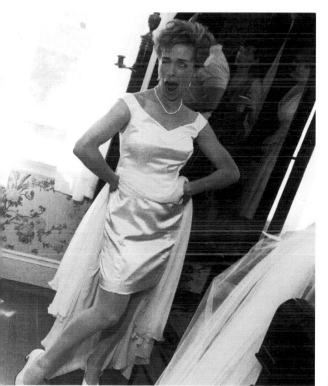

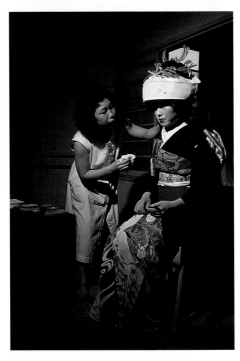

Hiroshima, Japan, 1956.

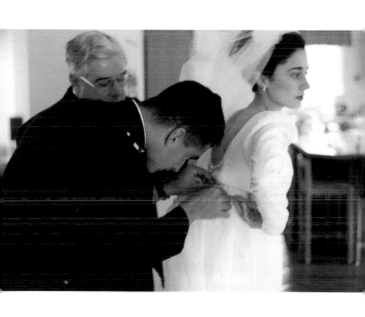

Pennington, New Jersey, 1994.

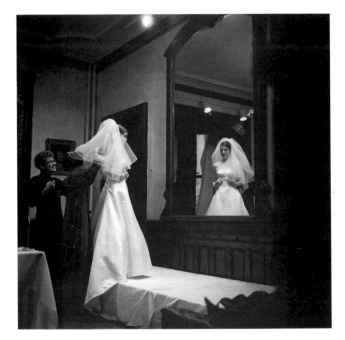

New York City, 1996.

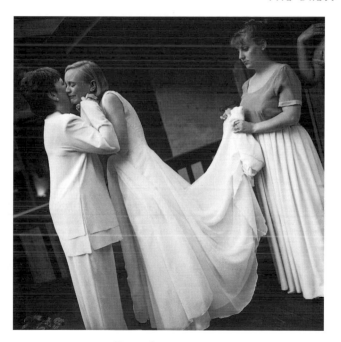

Pennsylvania, 1995.

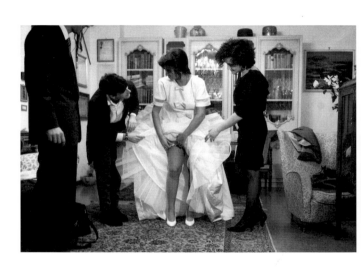

Italy, 1991.

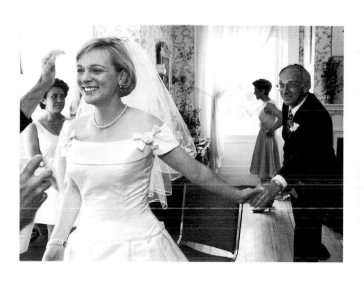

Massachusetts, 1996.

*T*here is something about a
wedding-gown prettier than in
any other gown in the world.

ଔ Douglas Jerrold

New York, 1960.

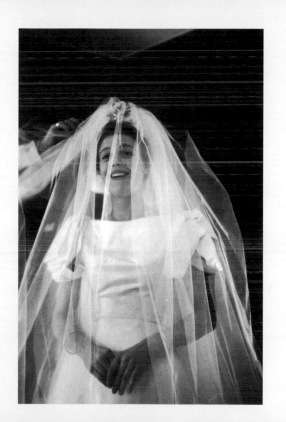

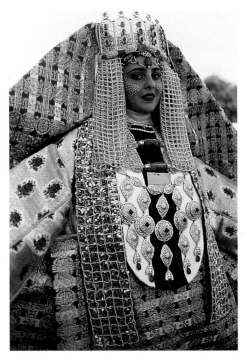

Morocco.

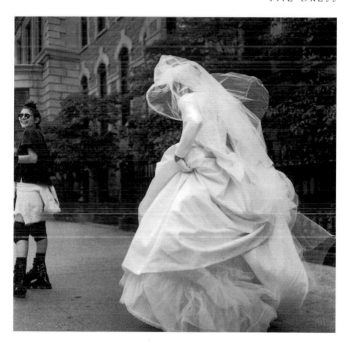

New York City, 1994.

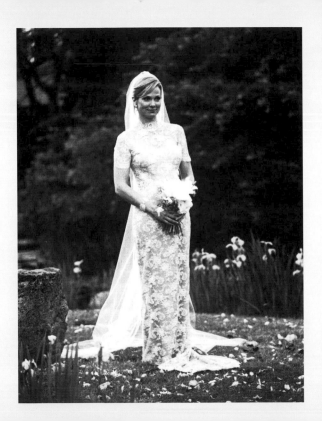

Delightful is the sight of her,
Radiant with shining beauty.
Her garments are like spring
 flowers,
And a scent of sweet fragrance is
 diffused from them. . . .

ೞ the apocryphal Acts of Thomas

New York, 1998.

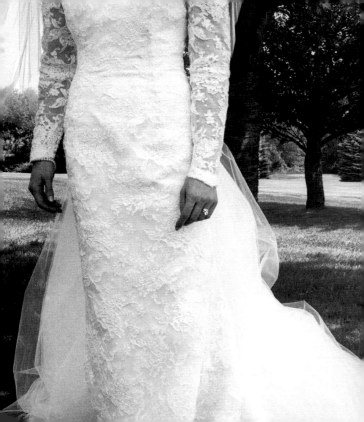

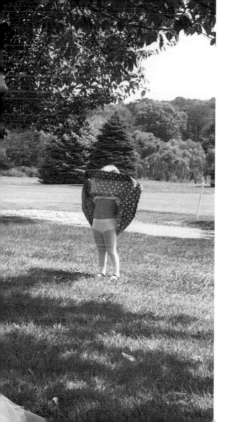

New Jersey,
1992.

51

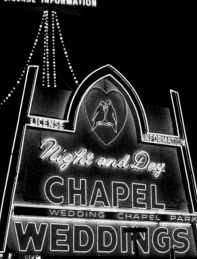

The Place

When we find ourselves
In the place just right
It will be in the valley
Of love and delight.

℘ Shaker hymn

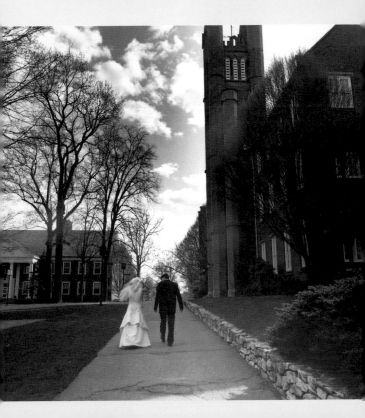

Now two are becoming one,
the black night is scattered,
the eastern sky grows bright.
At last the great day has come!

❧ Hawaiian song

*Opposite: Franklin & Marshall College,
Lancaster, Pennsylvania, 1998.
Overleaf: Chartres, France, 1997.*

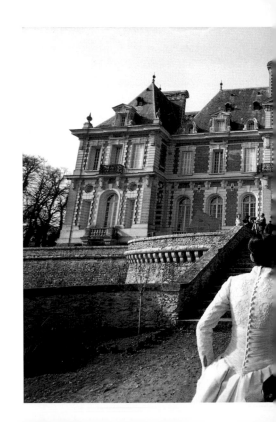

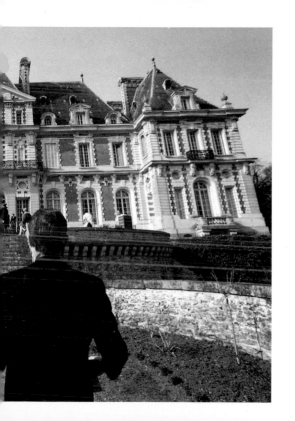

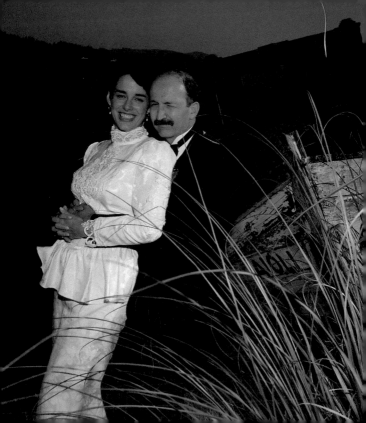

A successful marriage requires falling in love many times, always with the same person.

� Mignon McLaughlin

Oysterville, Washington, 1995.

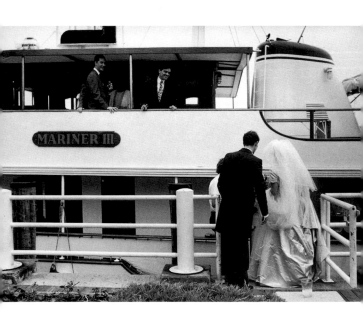

New York, 1990.

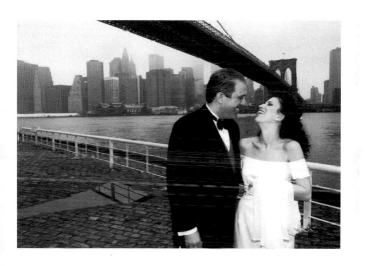

New York City, 1997.

*W*hat need of clamrous bells,

 or ribands gay,

These humble nuptials to proclaim or grace?

Angels of love, look down upon the place;

Shed on the chosen vale a sun-bright day!

 ‰ William Wordsworth

Municipal Building, New York, 1996.

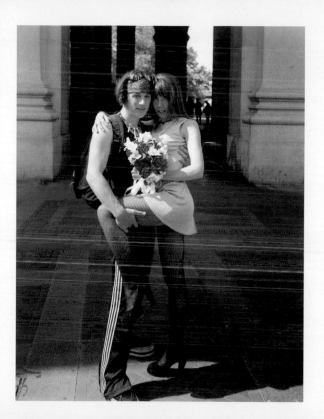

I'ts time to say words of
good omen
And to bring forth the
bridegroom and the bride.

☙ Aristophanes

Central Park, New York City, 1995.

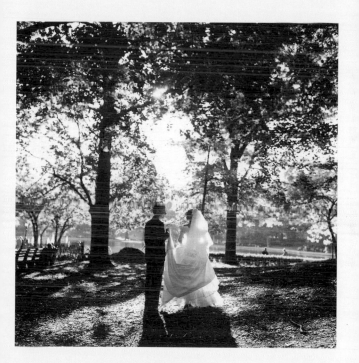

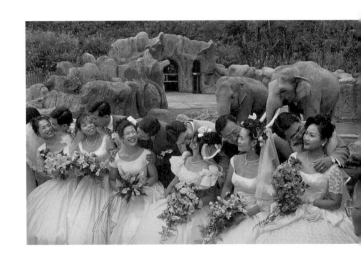

Taipei Zoo, Taiwan, 1997.

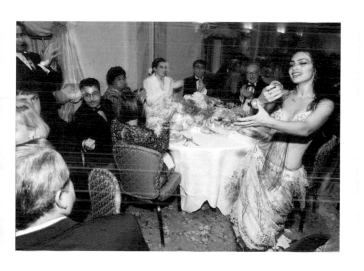

ABOVE: New York, 1993.
OVERLEAF: Bronx Botanical Gardens, New York, 1971.

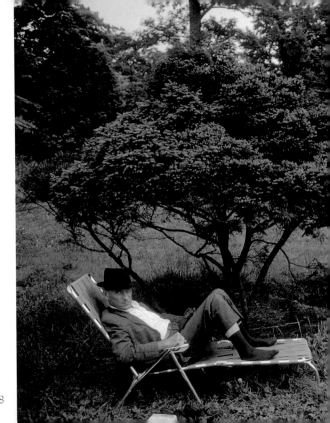

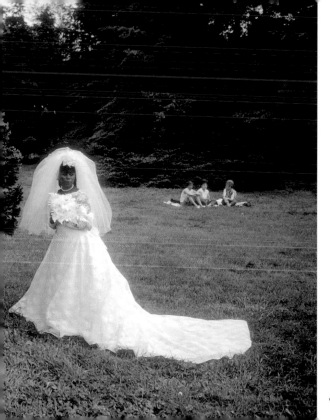

69

The bells they sound so clear.
Round both the shires they ring
them
In steeples far and near,
A happy noise to hear.

 ❧ A. E. Houseman

OPPOSITE: Brooklyn Heights, New York, 1998.
OVERLEAF: Cape Cod, Massachusetts, 1995.
PAGES 74–75: Priest preparing for scuba wedding ceremony, Bora Bora, 1994.

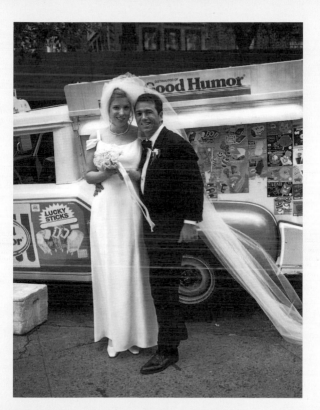

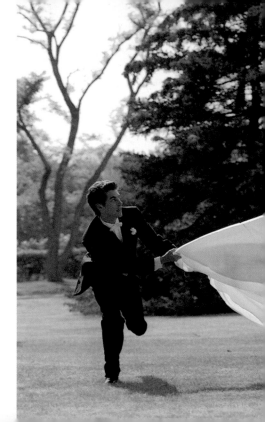

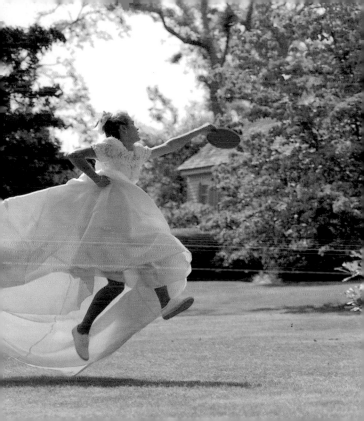

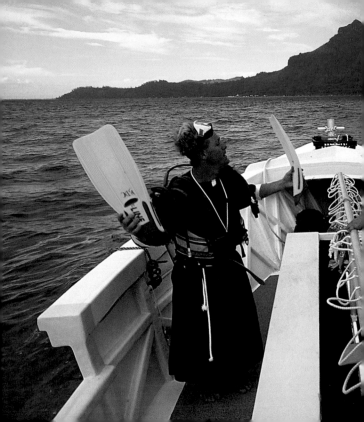

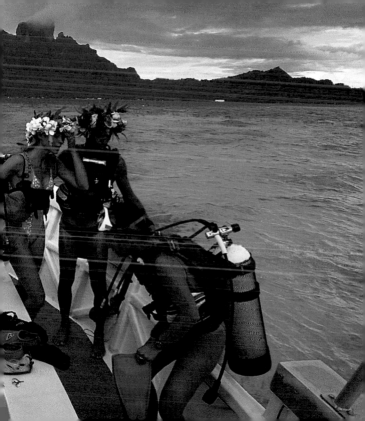

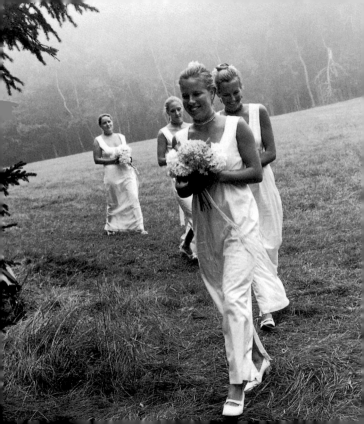

The Bride

A happy bridesmaid makes
a happy bride.

 Alfred, Lord Tennyson

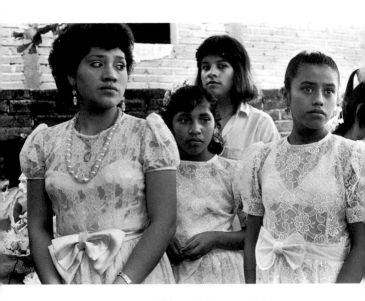

ABOVE: Yelppa, Mexico, 1988.
OPPOSITE: England, 1991.

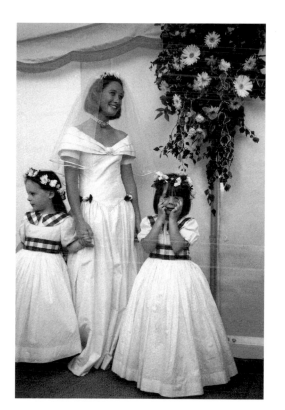

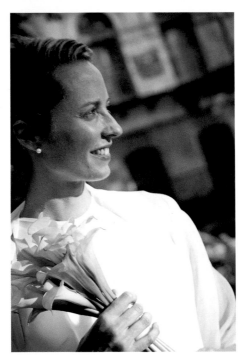

Tompkins Square Park, New York City, 1998.

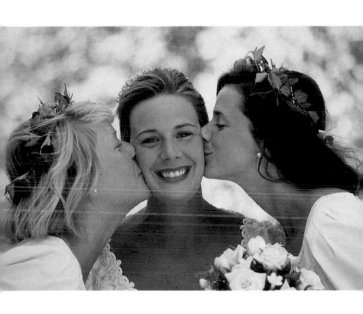

The joy of friends.

The bride hath paced into
 the hall,
Red as a rose is she.

 Samuel Taylor Coleridge

Bronx, New York, 1998.

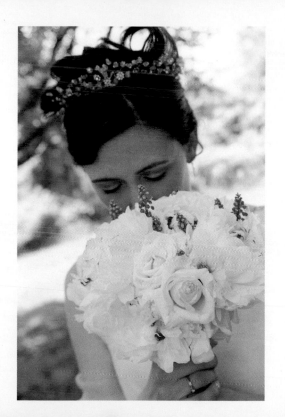

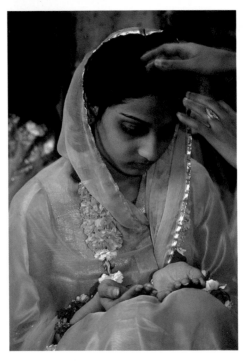

Jodhpur, Rajasthan, India.

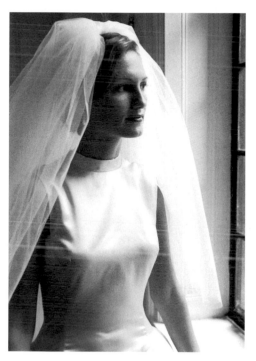

New York, 1997.

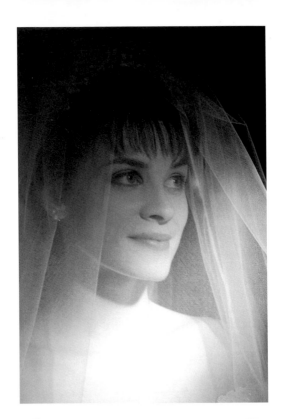

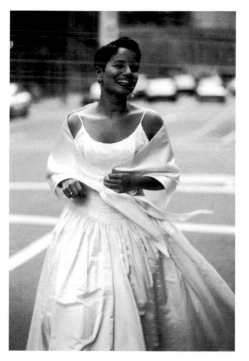

ABOVE: New York City, 1997.
OPPOSITE: New York, 1994.

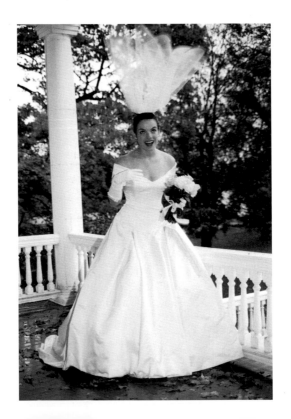

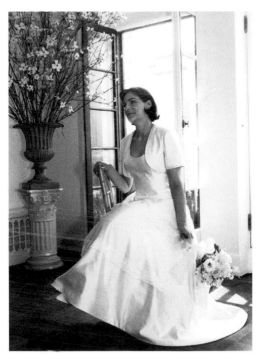

ABOVE: *New York, 1995.*
OPPOSITE: *Connecticut, 1996.*

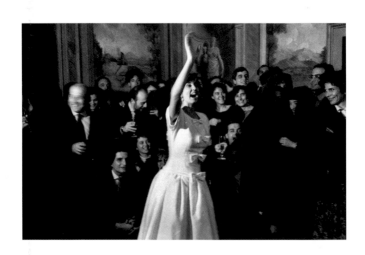

ABOVE: Italy, 1991.
OPPOSITE: New York, 1998.

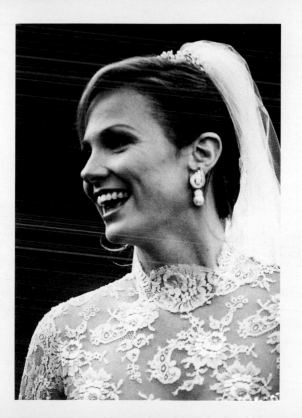

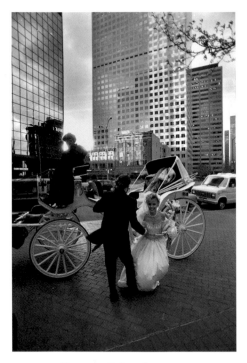

Denver, Colorado, 1992.

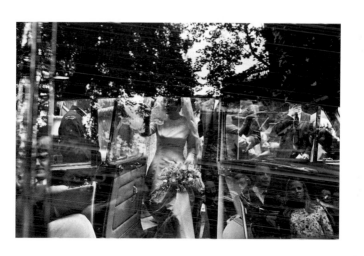

Brompton Oratory, London, England, 1947.

*F*or she was beautiful — her
 beauty made
The bright world dim, and every-
 thing beside
Seemed like the fleeting image of
 a shade.
 ✦ Percy Bysshe Shelley

East Hampton, New York, 1995.

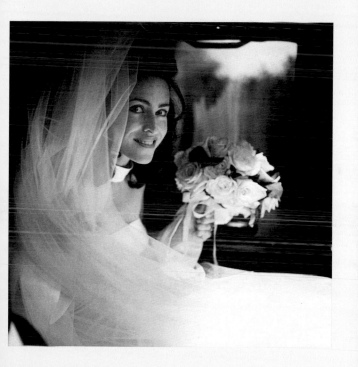

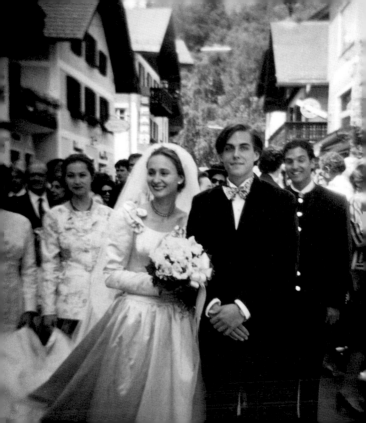

The Ceremony

Oh! let us be married,
too long we have tarried.
∽ Edward Lear

THE CEREMONY

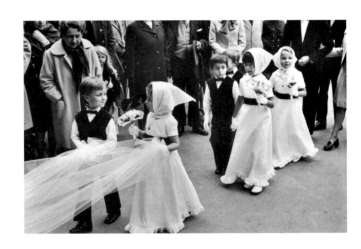

Paris, France, 1972.

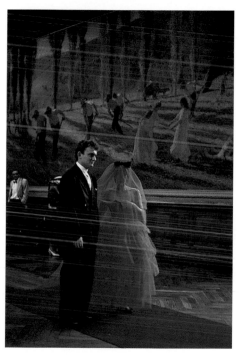

Hôtel de Ville, Toulouse, France.

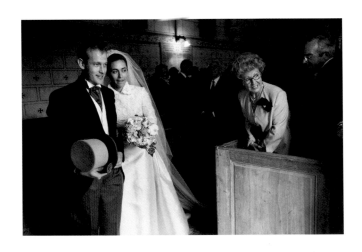

Chartres, France, 1997.

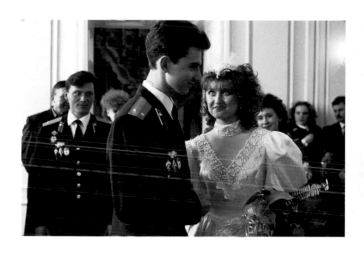

Moldavia, U.S.S.R.

They gave each other a smile
with a future in it.
℃ Ring Lardner

France.

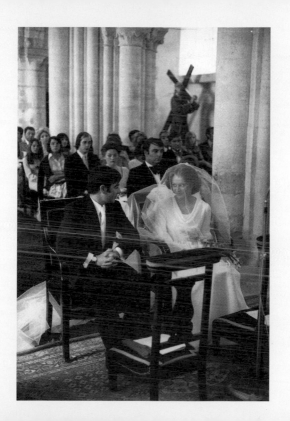

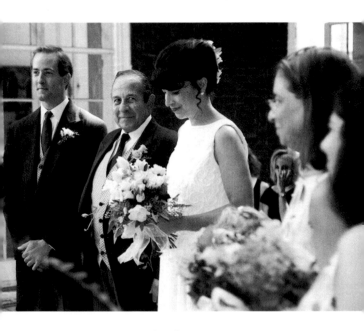

New Jersey, 1997.

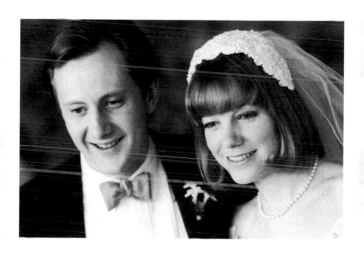

New York, 1990.

*H*ow but in custom and in
ceremony
Are innocence and beauty born?

☙ William Butler Yeats

Paris, France, 1995.

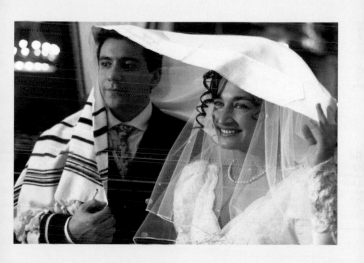

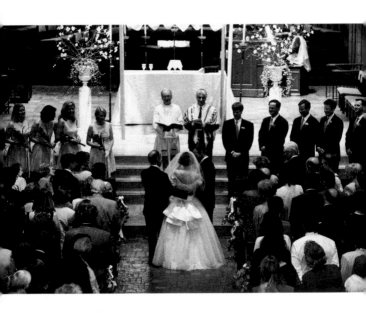

Pasadena, California, 1996.

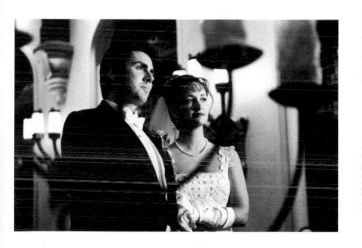

New York, 1997.

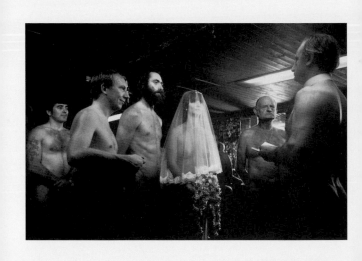

To church the parties went,
At once with carnal and devout
intent.

 ⁊ Alexander Pope

Kent, England, 1984.

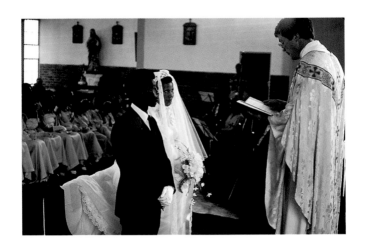

ABOVE: *Soweto, South Africa*.
OPPOSITE: *Luxembourg, 1991*.

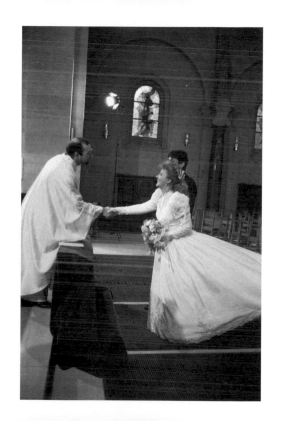

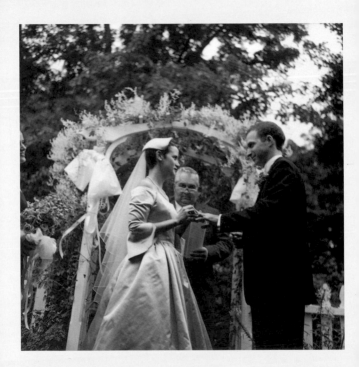

*M*arried couples who love
each other tell each other a
thousand things without talking.

℘ Chinese proverb

Rhinebeck, New York, 1996.

*M*arriage is a sign of the
union of the divine and
human natures.

 ❧ Johannes Tauler

India.

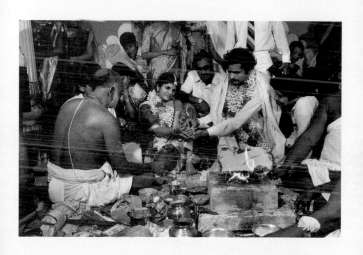

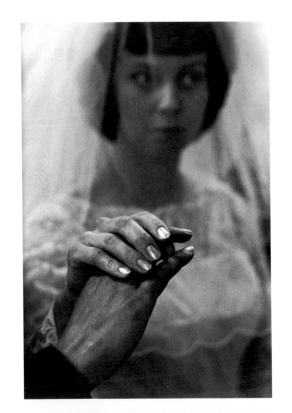

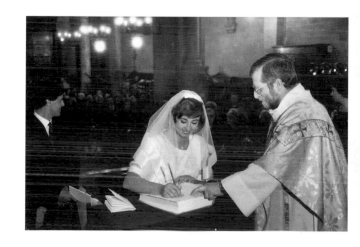

ABOVE: Italy, 1991.
OPPOSITE: England, 1963.

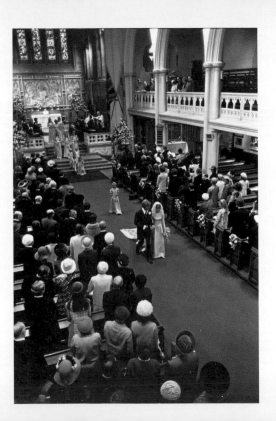

Make happy those who are near, and those who are far will come.

CB Chinese proverb

Brompton Oratory, London, England.

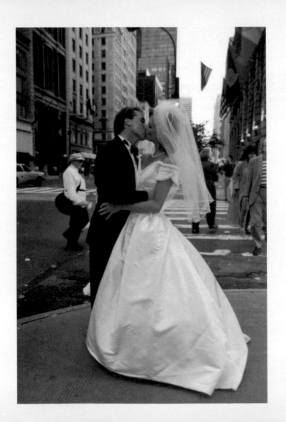

The Kiss

I am the sky. You are the earth. We are sky and earth united.

 ᚼ Hindi wedding rites

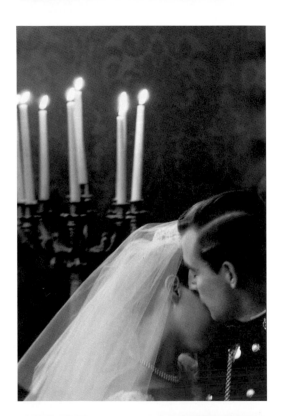

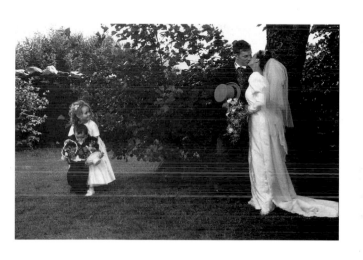

ABOVE: County Donegal, Northern Ireland, 1996.
OPPOSITE: New York, 1958.

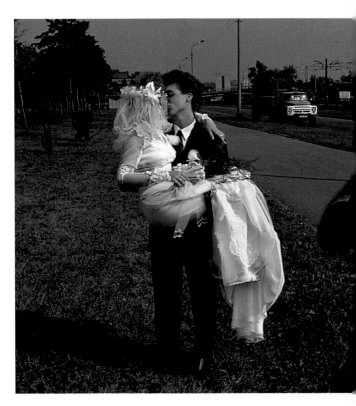

Kiev, Ukraine.

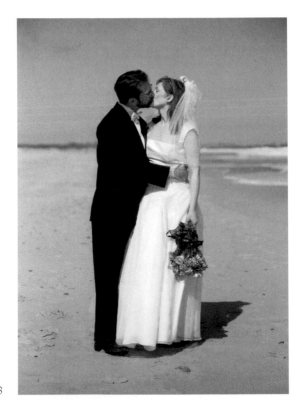

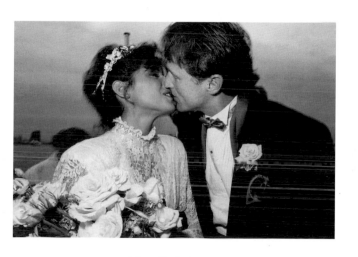

ABOVE: New York City, 1988.
OPPOSITE: New York, 1997.
OVERLEAF: New York, 1993.

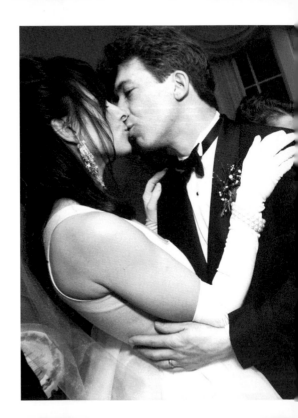

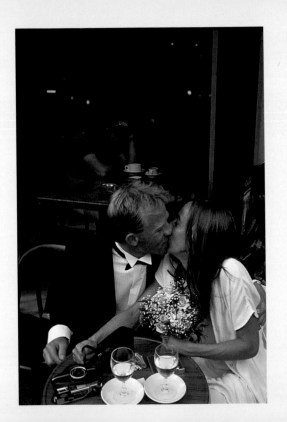

The sound of a kiss is not so
loud as that of a cannon,
but its echo lasts a great deal
longer.

❦ Oliver Wendell Holmes

OPPOSITE: Paris, France.
OVERLEAF: Massachusetts, 1994.

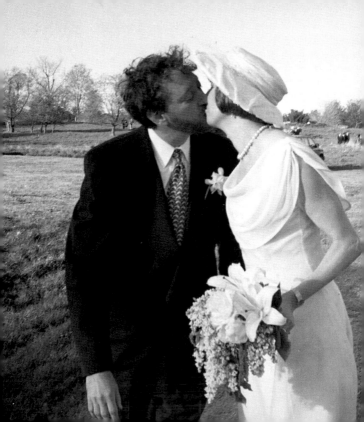

*K*isses honeyed by oblivion.

 ⅓ George Eliot

Roque Island, Maine, 1997.

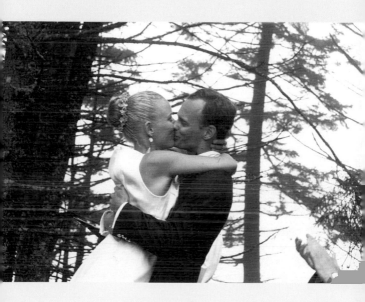

*H*e took the bride about the
neck
And kissed her lips with such a
clamorous smack
That at the parting all the church
did echo.

ɞ William Shakespeare

New York, 1996.

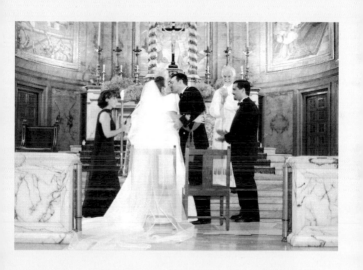

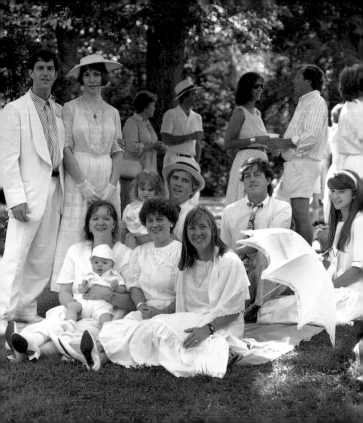

The Celebration

*A*nd you, all you good
wedding guests waiting in the
shadows, come out into the light!
May the light follow you!

℞ African wedding benediction

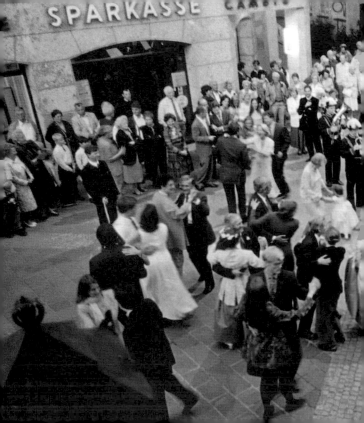

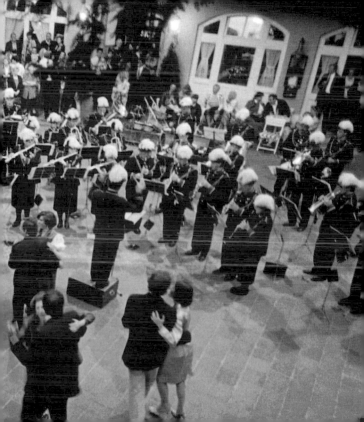

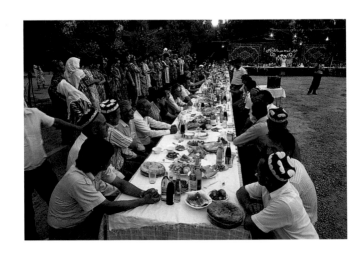

ABOVE: Dushambe, Tajikistan, 1990.
PRECEDING PAGES: Austria, 1995.

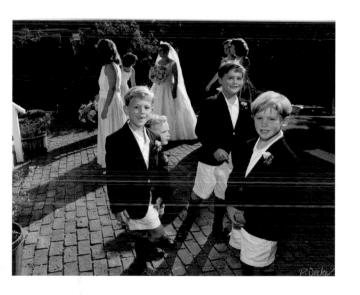

Fisher's Island, New York, 1996.

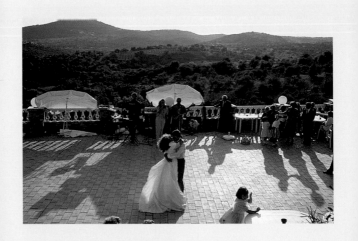

Their dance is our dance.

&3 Rumi

Portugal, 1992.

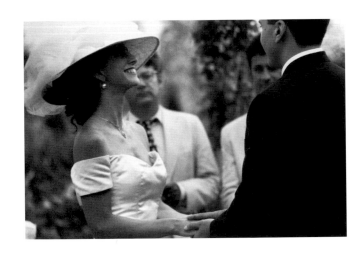

Sagaponack, New York, 1994.

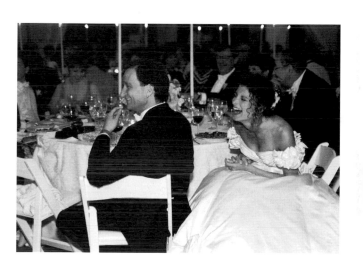

Pennsylvania, 1994.

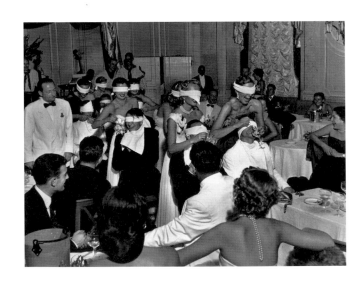

Biarritz, France, 1951.

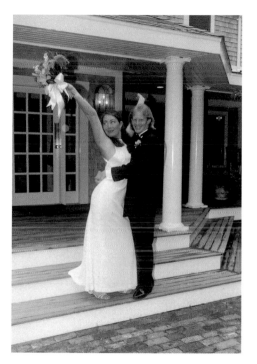

Martha's Vineyard, Massachusetts, 1998.

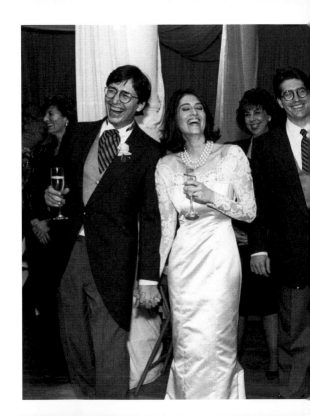

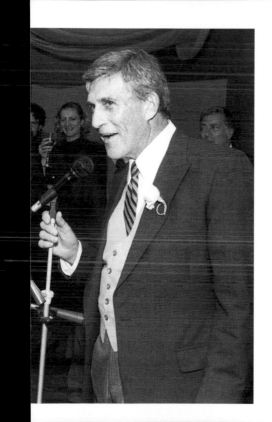

New York,
1990.

153

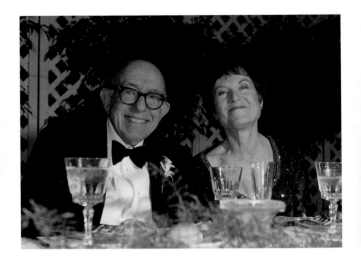

Cincinnati, Ohio, 1997.

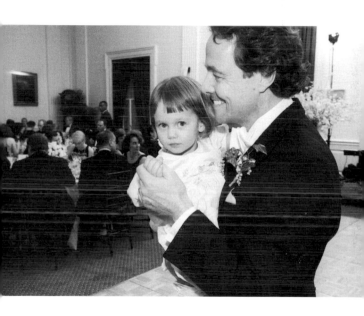

New York, 1998.

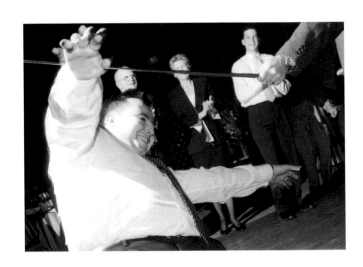

New York, 1997.

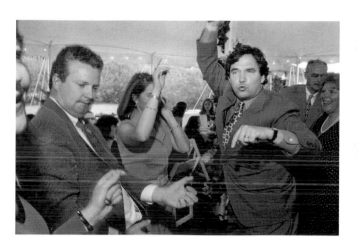

East Hampton, New York, 1997.

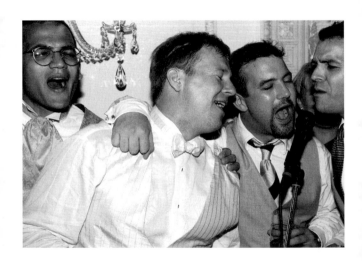

New York, 1997.

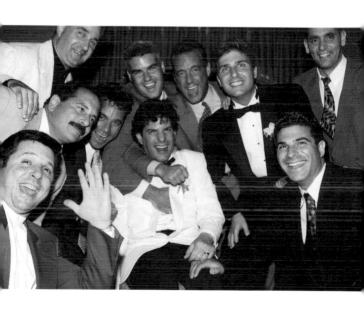

New Jersey, 1997.

159

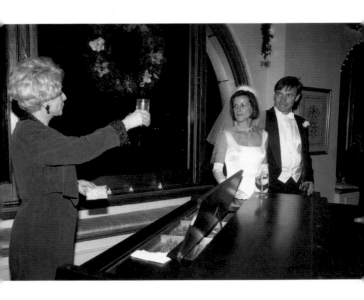

Mother of the bride toasts daughter . . .

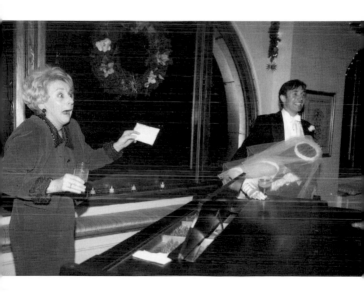

. . . and the wrong groom. New York, 1997.

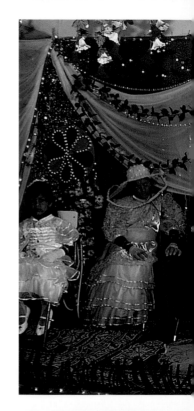

Muslim Wedding,
Mauritius, 1992.

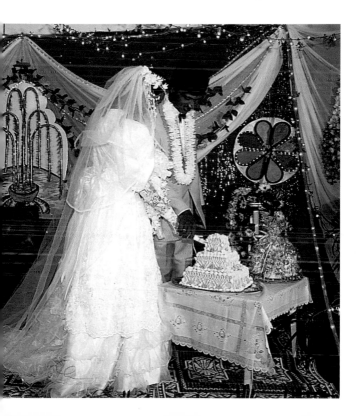

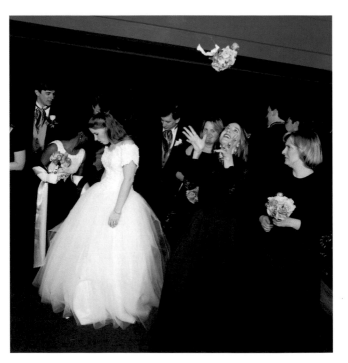

New York City, 1996.

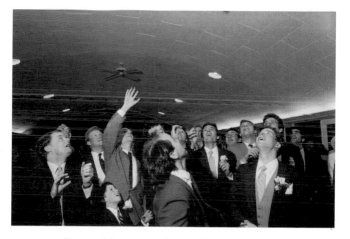

Pocono Mountains, Pennsylvania, 1990.

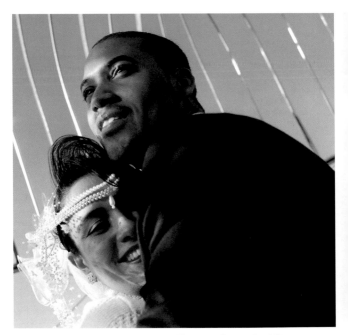

Valentine's Day, The Empire State Building,
New York City, c. 1994.

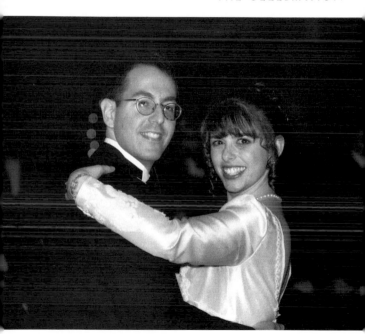

Cincinnati, Ohio, 1997.

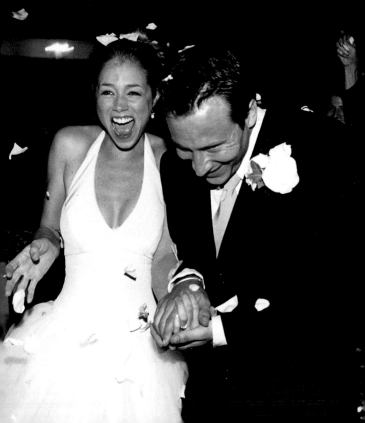

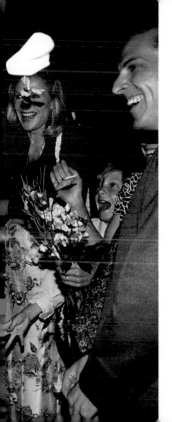

*Beverly Hills,
California, 1997.*

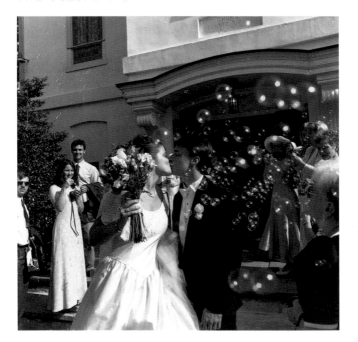

Glenmoore, Pennsylvania, 1996.

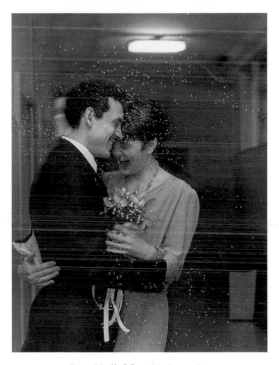

City Hall, New York, 1984.

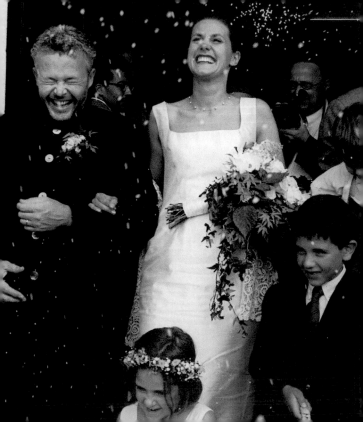

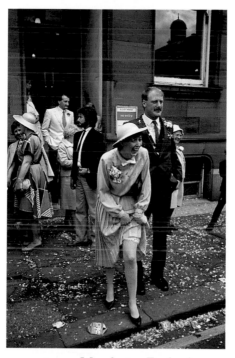

ABOVE: Manchester, England.
OPPOSITE: Austrian wedding in Venice, Italy, 1997. 173

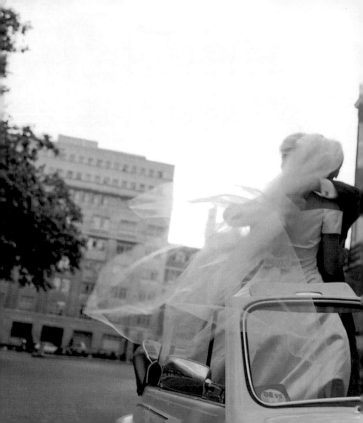

The Farewell

So, god of marriage, we've
 brought them
this far, and the rest of the song
is their singing. Be good to each other,
you two, and get to work on the singing,
on the labor of loving.

❧ Catullus

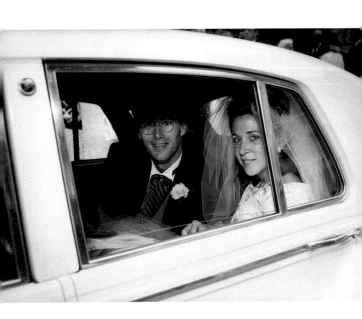

New York, 1990.

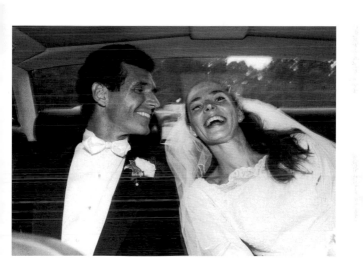

New York, 1990.

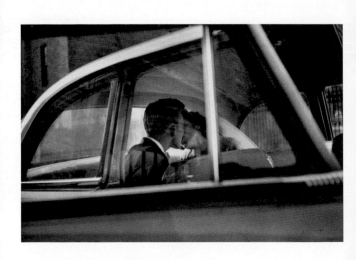

*T*here is nothing mightier and
nobler than where man and
wife are of one heart and mind.

 ℭℬ Homer

New York, 1955.

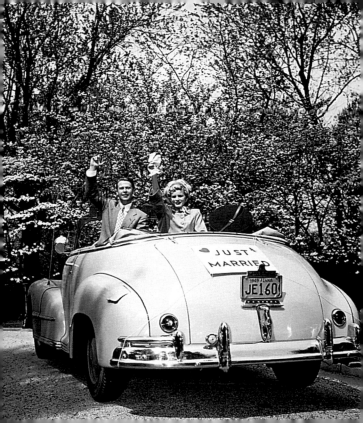

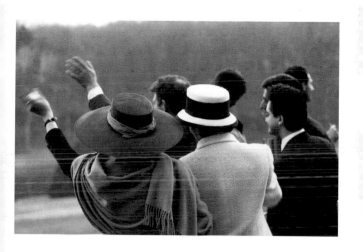

ABOVE: Temple Church, London, England.
OPPOSITE: Pennsylvania, 1949.

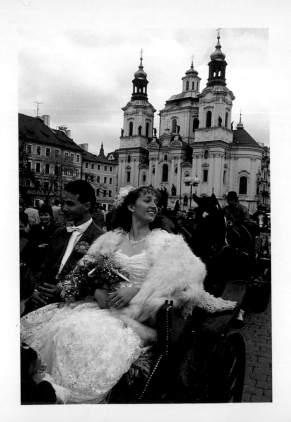

*W*e will be together
even when old age comes.
And the days in between
will be set before us,
dates and honey, bread and wine.

ઓ ancient Egyptian song

Prague, Czechoslovakia, 1992.

So now to your dwelling place,
To enter into your days together.

ɞ Apache song

OPPOSITE: Beville le Comte, France, 1997.
OVERLEAF: Roque Island, Maine, 1997.

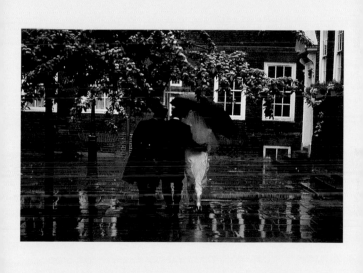

Photography Credits

The photographers and the sources of photographic material other than those indicated in the captions are as follows:

Copyright © Abbas/ Magnum Photos, Inc.: 42, 90, 119, 144, 163; Copyright © Archive Photos: 6, 23, 180; Copyright © Eve Arnold/Magnum Photos, Inc.: 45, 118; Copyright © Robert Baldridge: 140, 172; Copyright © Bruno Barbey/ Magnum Photos, Inc.: 29, 126, 182; Copyright © Ian Berry/Magnum Photos Inc.: 173; Copyright © Randy Bick: 154, 167; Copyright © Andrea Booher/Tony Stone Images: 84; Copyright © Rene Burri/Magnum Photos Inc.: 92; Copyright © Robert Capa/Magnum Photos Inc.: 150; Copyright © Chien-Chi Chang/Magnum Photos, Inc.: 66; Copyright © Chmelar/Griffith: 71;

First edition
10 9 8 7 6 5 4 3 2 1

Library of Congress Cataloging-in-Publication Data
Murphy, Timothy, 1969–
 Weddings / text by Timothy Murphy. — 1st ed.
 p. cm. — (A miniSeries book)
 ISBN 0-7892-0524-6
 1. Weddings. 2. Marriage customs and rites. I. Title.
II. Series
GT2665.M89 1999
392.5—dc21 98-32058

About the Author

TIMOTHY MURPHY is a freelance writer living in New York. His other books include *A Literary Book of Days* and two novels, *Getting Off Clean* and *The Breeders Box*.

On the occasion of:

••

••

Highlights:

••

••